DOUBLE ELEPHANT

MANUEL ÁLVAREZ BRAVO

DOUBLE ELEPHANT / EDITED BY THOMAS ZANDER

DOUBLE ELEPHANT

Manuel Alvarez Bravo

STEIDL GALERIE THOMAS ZANDER

FIFTEEN PHOTOGRAPHS BY MANUEL ÁLVAREZ BRAVO

Generally speaking, photography has till now been content to show us Mexico from the facile angle of surprise such as it can be experienced by any foreign eye at virtually every turn. As a result, what we end up with is the most eclectic but at the same time most disappointing documentary imaginable, for which the panoramic sites, the Indian dances, and the baroque architecture dating from the colonial period must share a large part of the blame. Whether one leafs through these stacks of fleeting impressions or witnesses on the spot this constant, mechanical, essentially insensitive click of the camera, one is tempted to conclude that the soul of Mexico will never be bared through the medium of photography. The full essence of the country, one suspects, can only be revealed by someone who has known it since childhood and who, ever since, has never stopped probing and questioning it with love and passion. That is precisely what Manuel Álvarez Bravo has succeeded in doing in his incomparable photographic compositions, which I can only describe as of an admirable synthetic realism, the like of which, at least to my knowledge, does not exist. What he has done is to make the full range of Mexican pathos – all its many moving and touching facets – fully understandable to us; any place that Álvarez Bravo has stopped to aim his camera, whenever he has paused to record a play of light, a gesture, some absolutely distinctive moment, or a silence, not only do we know that there lies the beating heart of Mexico but that it is in such moments and at such places that the artist has been able to have a presentiment – in an act of unique discretion – of the fully objective value of his emotion. In a work such as *A Worker Killed in a Fight*, where inspiration and infallible technique combine and act as one, Manuel Álvarez Bravo has managed to raise his art to the rare height that Baudelaire once described as "the eternal style."

André Breton
From his preface to the 1939 show, "Mexico",
held at the Renou & Colle Gallery in Paris

A portfolio of fifteen photographs published in a limited edition of seventy-five copies and fifteen artist's proofs. Each print has been signed and numbered by the photographer. All photographs were printed by the photographer. The photographs have been mounted on 4-ply, Strathmore Artist Bristol. The paper was embossed by Kathleen Caraccio and Catherine Carine of The Printmaking Workshop. The portfolio was designed by Louis Dorfsman and manufactured by Brewer-Cantelmo Co., Inc. The text sheets were printed by Tri-Arts Press. The introductory essay was written by André Breton and translated by Richard Seaver. The project editors were Burton Richard Wolf, Eugene Stuttman, and Lee Friedlander.

Edited by Lee Friedlander for The Double Elephant Press Ltd., 205 East 42nd Street, New York, New York, 10017.

1

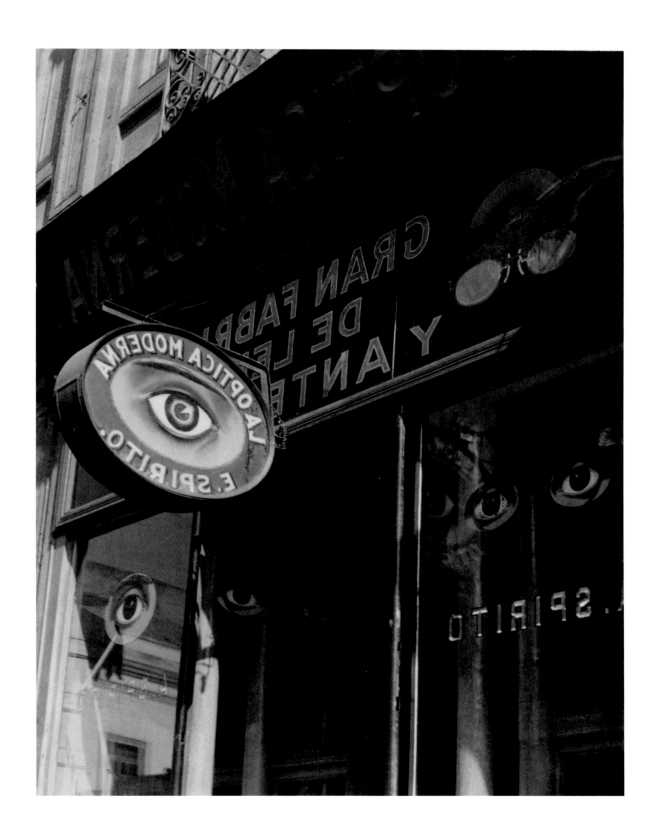

2

3

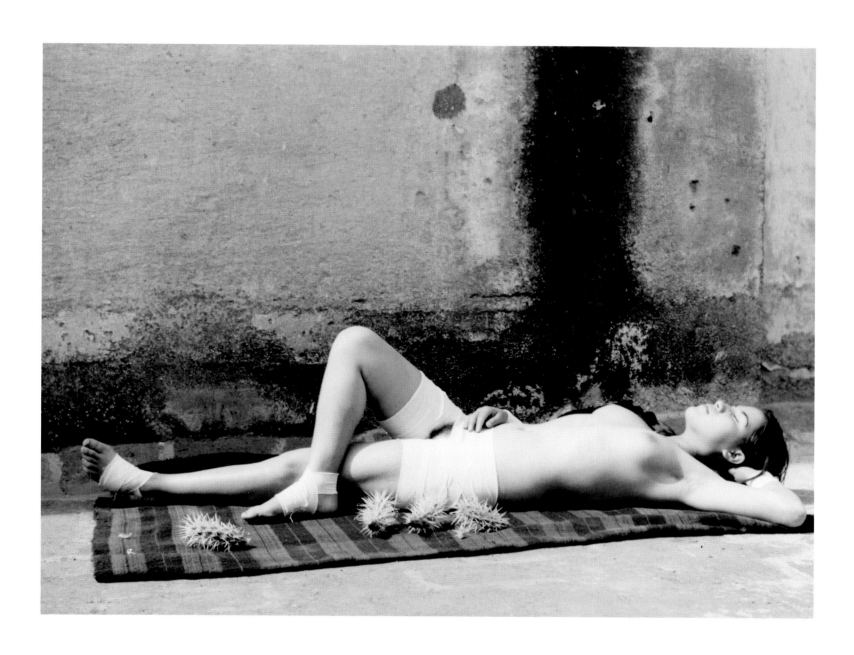

4

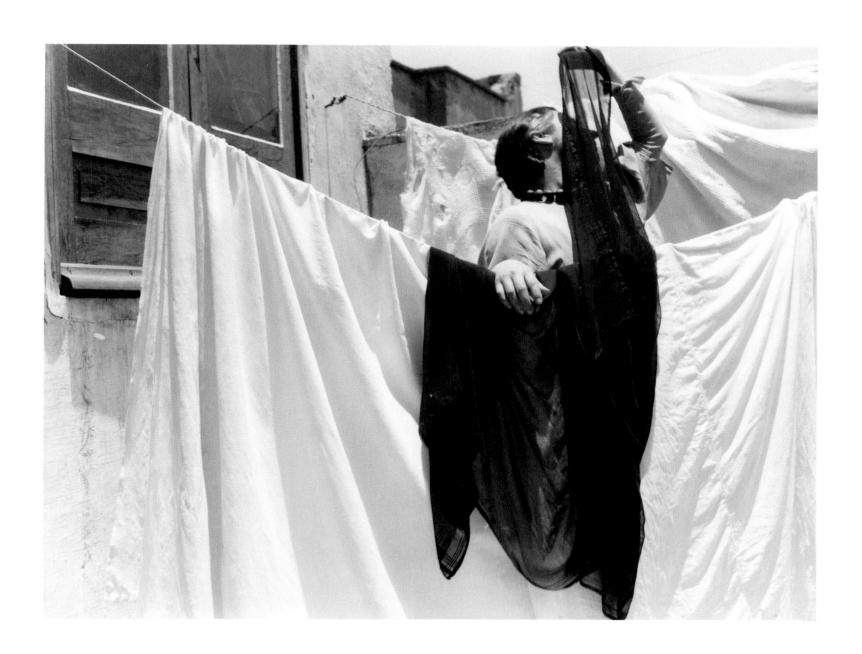

5

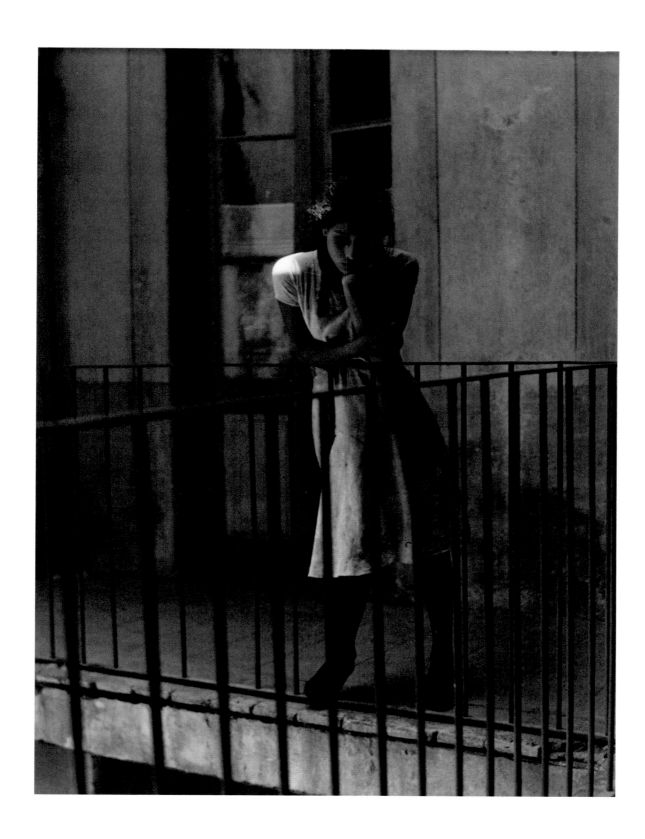

6

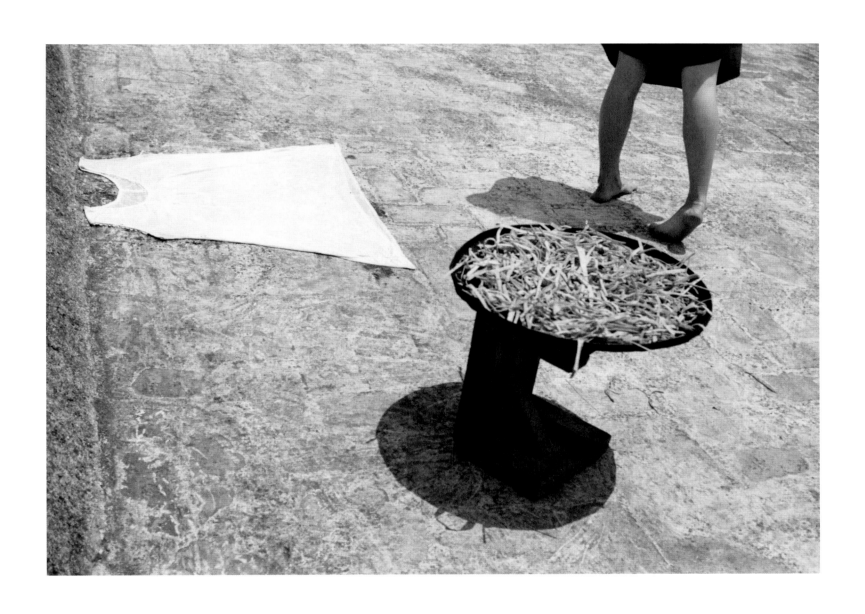

7

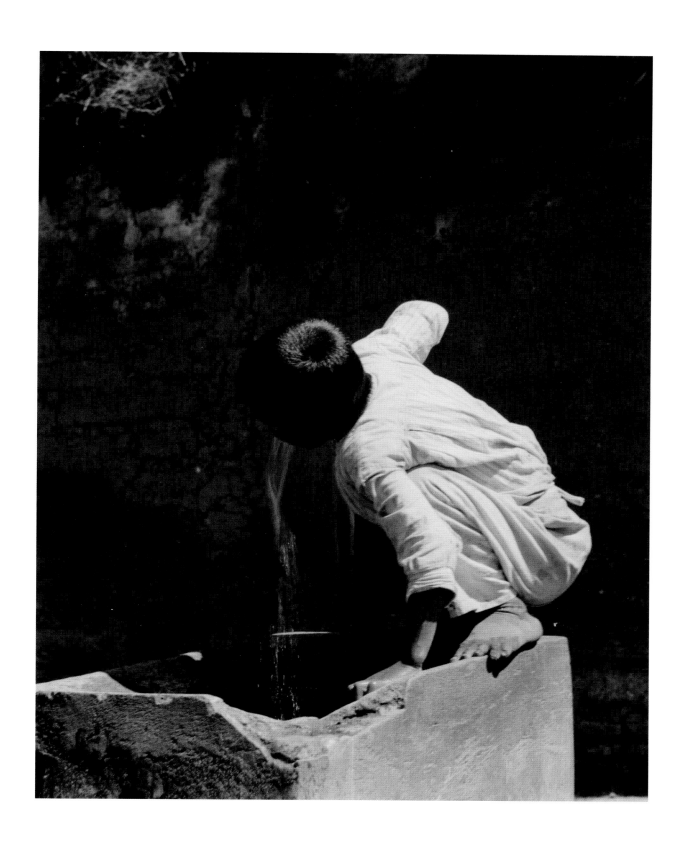

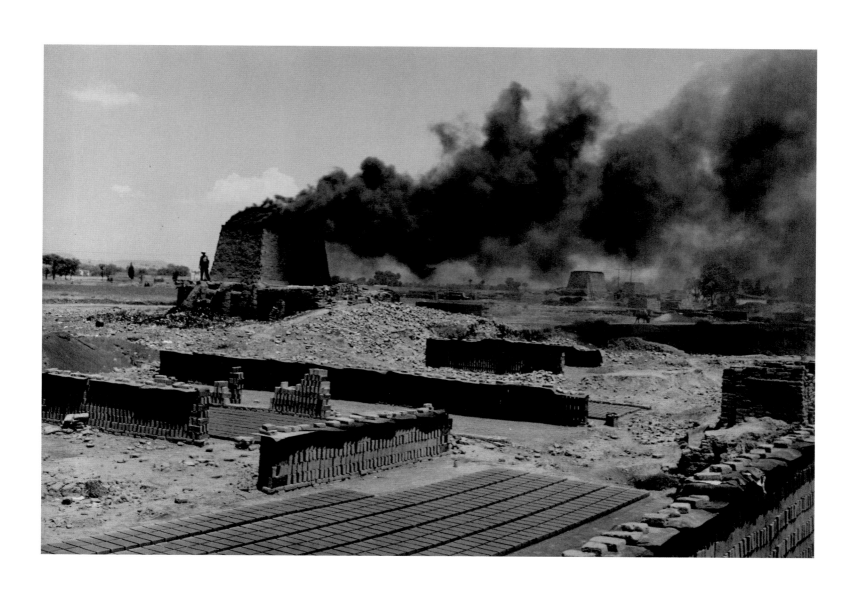

9

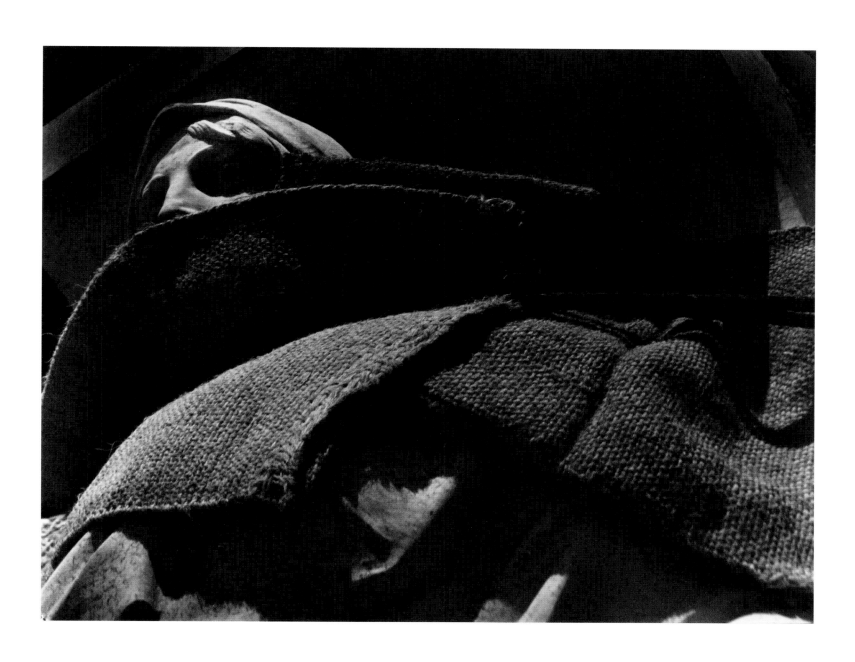

10

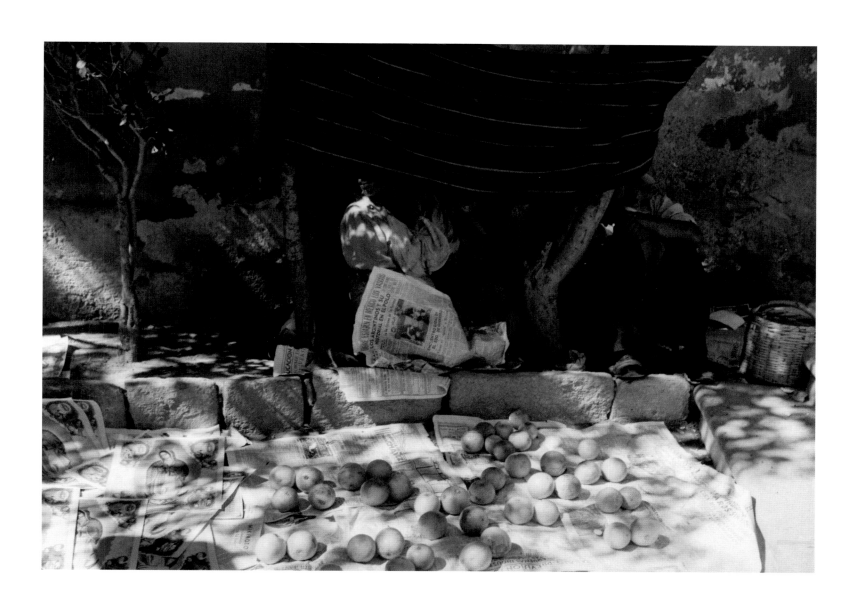

11

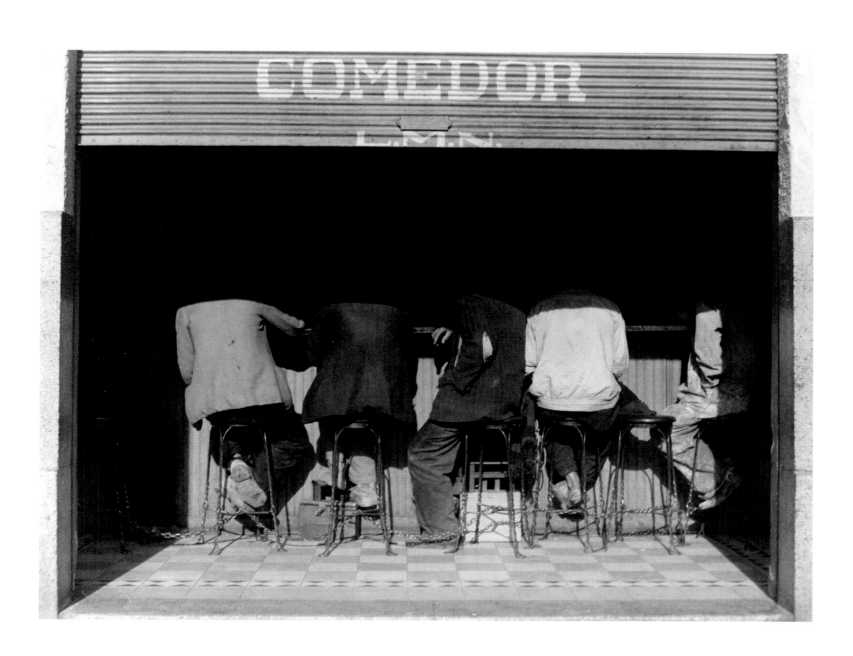

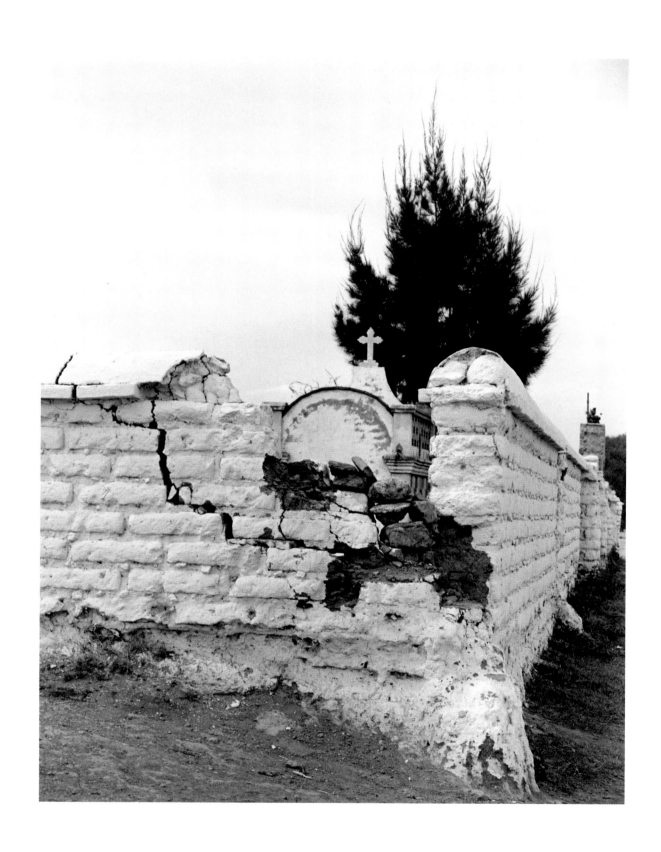

13

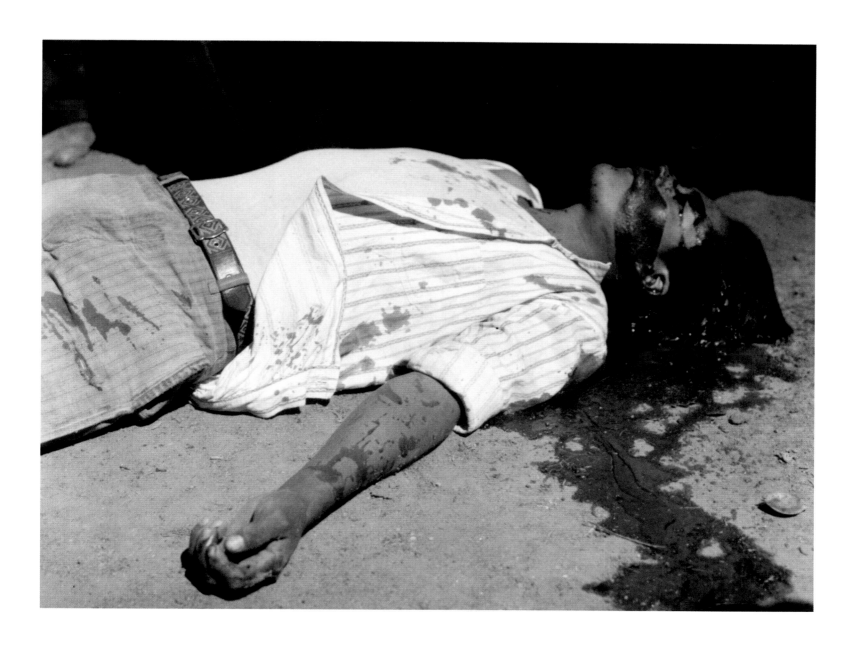

14

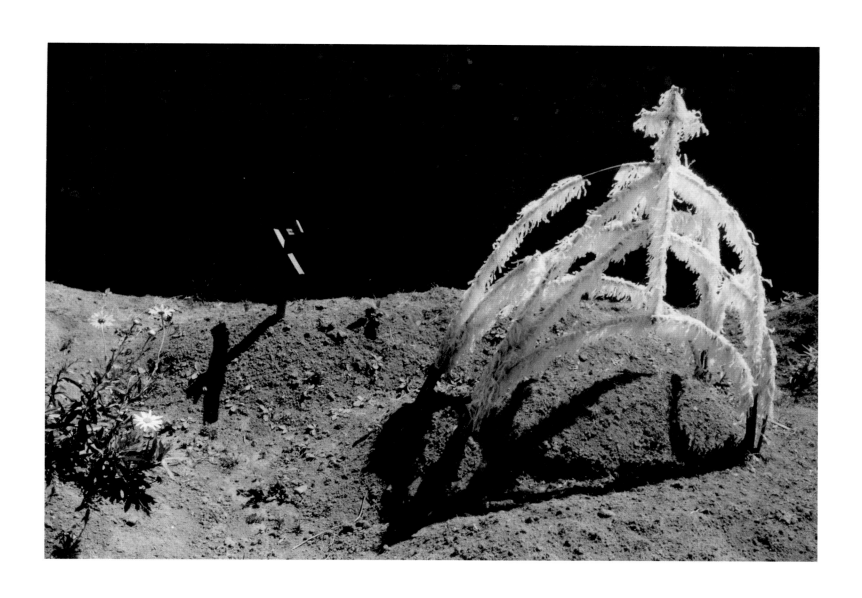

15

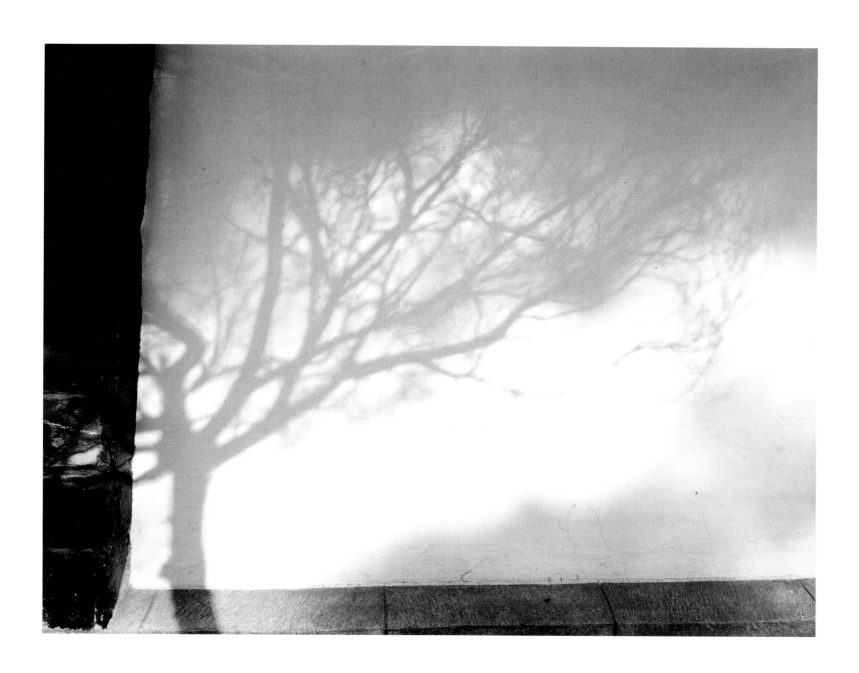

First book edition published in 2015

Image sequence, portfolio description, and introductory
text by André Breton from the original portfolio.

Editor: Thomas Zander
Project management: Frauke Breede, Anna Höfinghoff
Copyediting: Keonaona Peterson
Book design: Duncan Whyte, Bernard Fischer, Sarah Winter, Gerhard Steidl
Tritone separations by Steidl
Production and printing: Steidl, Göttingen

Steidl
Düstere Str. 4 / 37073 Göttingen, Germany
Phone +49 551 49 60 60 / Fax +49 551 49 60 649
mail@steidl.de
steidl.de

Galerie Thomas Zander
Schönhauser Str. 8 / 50968 Cologne, Germany
Phone +49 221 934 88 56 / Fax +49 221 934 88 58
mail@galeriezander.com
galeriezander.com

ISBN 978-3-86930-743-5
Printed in Germany by Steidl